THE JURASSIC COAST

A POET'S JOURNEY

The Jurassic Coast
Coast
A Poet's Journey

Amanda K Hampson

Illustrated by

Sheila Haley

THE HOBNOB PRESS

First published in the United Kingdom in 2021

by The Hobnob Press,
8 Lock Warehouse, Severn Road, Gloucester GL1 2GA
www.hobnobpress.co.uk

British Library Cataloguing in Publication Data
A catalogue record for this book is available from the British Library

ISBN 978-1-914407-00-0 (paperback)
 978-1-914407-01-7 (casebound)

Typeset in Adobe Garamond Pro 12/14 pt.
Typesetting and origination by John Chandler

'This precious stone set in the silver sea'

WILLIAM SHAKESPEARE

Contents

Introductory Note

My first visit to the Jurassic Coast in Dorset, was on a geology field trip for my A-level studies in the mid-1970s. The breathtaking beauty and wildness of this stretch of coast has drawn me back time and again over the past few decades, and seemed both a natural and inspiring subject for my second book of poetry, as a companion to my first volume, *A Celebration of Wiltshire in Poetry*.

In 2001, the Jurassic Coast became England's first natural World Heritage Site, being recognized as a place of outstanding universal value, to be protected, conserved and passed intact to future generations. Its 95 miles of dramatic cliffs, tumbling landslides, spectacular arches and sea stacks display 185 million years of Earth's history, and provided me with great riches for the poetry that follows.

My thanks go to Sheila Haley, for her wonderful and vibrant illustrations that accompany my poems; to my husband Keith for all his technical support and valuable comments as a second pair of eyes; and to John Chandler of Hobnob Press, for being willing to publish a second book of my poetry.

I hope you will enjoy this collection of varied and illustrated poems.

Amanda K Hampson
January 2021

Rocks and Fossils

The most astonishing rock formations and collections of fossils can be seen all the way along the Jurassic Coast - rich inspirations for the poems in this chapter. The geological walk through time from west to east presents us with successively younger rocks from Exmouth to Studland.

As well as the preserved marine beds and their fossils, the colours of the Jurassic Coast are truly stunning; *Golden Cap* really is golden, as is the sandy east cliff at Burton Bradstock, featured in *Burton Cliff*. The older rocks around Exmouth are typified by Otter Sandstone, which is a rich red colour (hence the poem *The Red Sea*), and the younger chalks at Studland are a brilliant white (see page 91). In contrast, at *Kimmeridge Bay*, the shales are a tarry black.

I love the walk from Lulworth Cove over the hill to *Durdle Door*, and have devoted three poems to this part of the coast, to include the oddity that is The *Lulworth Crumple*. The forces of nature have fashioned over millennia some of the most dramatic sights anywhere in the British Isles. On another walk one stormy day at Charmouth, I was very happy to take refuge in the Charmouth Heritage Coast Centre, whereupon I discovered the museum exhibit of the Sea Dragon! The *Sea Dragon* is actually an ichthyosaur that Chris Moore discovered in fallen rocks on the beach in the winter of 2015/16. My little adventure at Charmouth would therefore have been very satisfying, had I not left my walking shoes in the car park as I drove away!

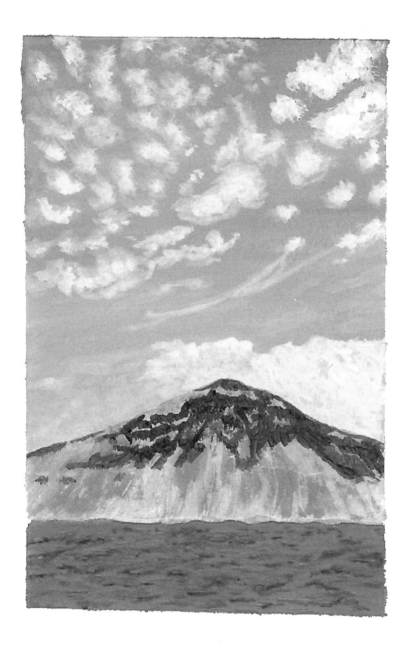

Golden Cap

'The crows and choughs that wing the midway air
Show scarce so gross as beetles...
The murmuring surge,
That on the unnumbered idle pebbles chafes,
Cannot be heard so high.'

<div align="right">William Shakespeare, King Lear, Act 4, Scene 6.</div>

The toil of the climb, with the sting of driving rain and
 the pricks of blackthorn,
gives way to a tranquillity,
a stillness of being,
of being high above the murmuring sea
and the gulls and crows wheeling five hundred feet up,
yet still below us!

This plateaued cliff,
seeming of honeycomb in sunlight,
cleaves a big coastal sky
as it looms proud,
its neighbouring Langdon Hill
a protective companion,
a dog lying at heel.
And far off
sit the great lumbering cow and calf,
the hills of Pilsdon and Lewsdon,
in repose on their haunches,
in reverence to this gleaming high point
between The Wash and Land's End.

Inspired in part by F J H Darton, *The Marches of Wessex*, 1922.

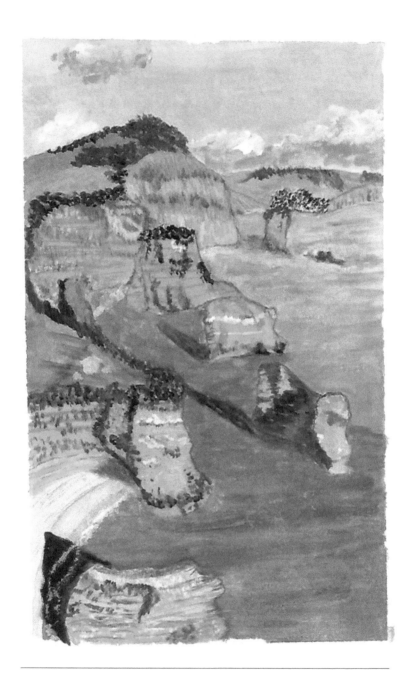

The Red Sea

Upon seeing the gigantic sea stacks at Ladram Bay,
it was not just the rocks that caught my attention that
stormy day.

But the red, red sea sucking at the shore,
like the blood of the devil from the ocean floor.

The rusty surf swirling round sandstone beds,
just as woodstain washes from the painter's shed.

But why along this part of the coast,
does nature have red cliffs to boast?

The ancient landscape was a hot dry plain,
where rivers meandered and rocks were lain.

Iron and minerals were buried under pressure,
and over millennia the sea and the weather

fashioned the orange headland we see,
parted at the tip by the Otter Estuary.

The red, red sea sucking at the shore,
cuts through the headland, leaving a door.

And so the stacks will be gone eventually,
and with them the nesting birds and their sanctuary.

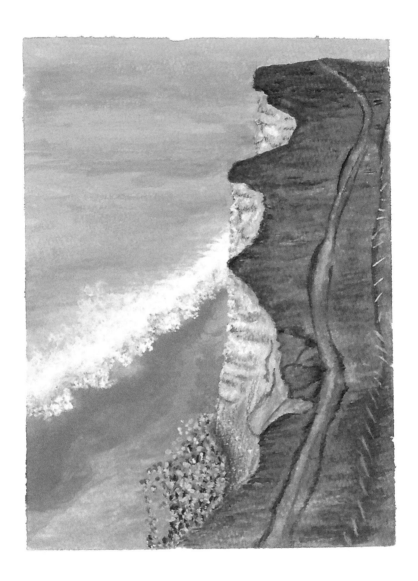

Burton Cliff

This golden shoulder of the coast
is a honey coloured layer cake.
Noses of calcite
and bony elbows of oolite
poke out like walnuts
from the softly hollowed sands.
A storm brings fresh landfalls,
veined with glistening quartzite
and cracked open with ammonites,
strewn on the shallow beach
like crumbs from the cake;
gold nuggets of pyrite
break free for dazzled fools.
A gull flies up
from an icing of Fuller's Earth,
and scornful of the storm,
soars away on the wind
towards an insurgent sea.

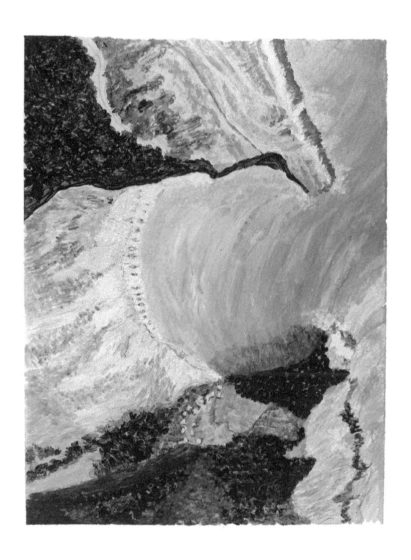

The Ballad of Lulworth Cove

Once a river came swollen,
soon after the ice age,
and flowed overland to meet
a rising sea on the rampage.

The river cut a valley,
and ran down through the rocks,
it breached the Portland stone
but left untouched the chalks.

Together the river and sea
scooped out the soft sands and clays,
and formed Lulworth Cove
the most beautiful of bays.

The Cove is perfectly formed,
a sheltered natural harbour,
shaped like a scallop shell,
a real Jurassic treasure.

Go down to the Cove today,
see the bright blue boats and lobster pots,
against the whiteness of chalk,
a most visited of beauty spots.

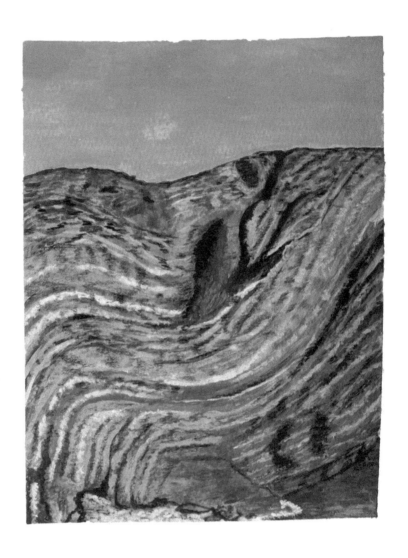

Lulworth Crumple

Just over from the Cove is the Crumple,
where layered rocks once level,
were tilted and twisted as through a mangle,
leaving a very curious rumple,
from earth movements very forceful.

The rocks are dipping at an angle,
arches, stacks and stumps all a-jumble;
a small inlet has appeared in the middle,
from a breach by a sea that is tidal,
it's a unique view quite wonderful.

Geologists with their hammers will travel
quite a distance to see the Crumple;
for a good view it's a bit of a scramble,
over Portland and Purbeck rubble,
and shale that's taken a tumble.

It's all a bit of a muddle,
but where else would you stumble
on a coastal scene so unusual.
So if you're on a coast-path ramble,
be sure to visit the Lulworth Crumple.

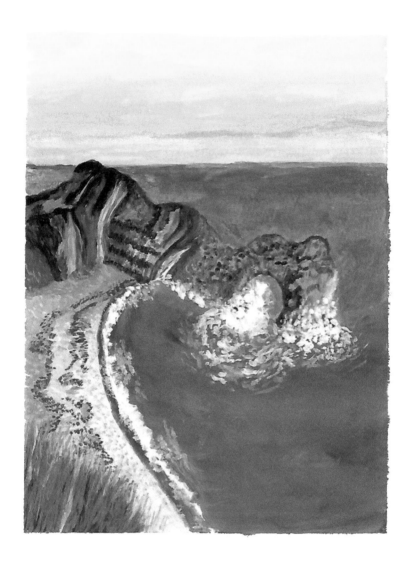

Durdle Door

The path leads away from Lulworth and over the hill,
a long scar in the chalk from the walker's tread.
The sinking sun bleeds away over a Jurassic spectacle
that awaits the faithful:

Hunched shoulders of stone
stoop as if to drink,
and a reptilian neck
bends majestically into the waves,
arched from the pounding and slapping
of a savage sea.

Ceaselessly
the tide throws itself
through the hollow between chin and chest,
and inexorably into a vortex,
tossing its jewels onto the shingle shore.

And one day the limestone torso will fall,
from the thirling of a remorseless sea.

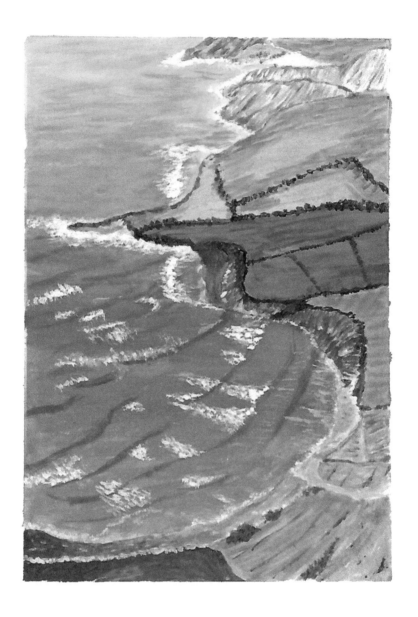

Kimmeridge Bay

At Kimmeridge the rocks are black as tar,
organic, oozed, foul-smelling with oil,
engorged with detritus from tropical seas past.
A slice of geological time.
Erosion has forged her jagged remnants,
clean-faced from fracture,
pargeted with ammonites
seeing light for the first time.

The incoming tide has no need
to conquer the shore
with thunderous surge,
but makes quiet advance
with shallow wavelets,
rippling across the tarry ledge
that lies beneath,
like sheets smoothing on a bed.

And high up on the west cliff for all to see,
the Nodding Donkey,
silently pumping since nineteen-sixty-three.

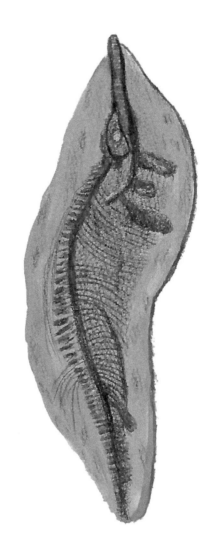

Sea Dragon

Afloat in the warm Jurassic seas
two hundred million years ago,
way ahead of the big freeze
before glaciers began to flow,
a huge monster swam by,
with huge teeth and a six foot head,
he surely had me in his eye,
looking to be fed.
He opened his maw
to seize his prey,
got me in his jaw
and I sank to the clay.
Along with plants and shells
pressed together we became stone,
and as fossils we happily dwelled
in a sedimentary zone.
And when the seas receded
we became the Jurassic Coast,
golden sandy rock bedded,
beauty for UNESCO to boast.
But then a few years back,
massive storms and a hurricane
forced the rock to crack,
and showed where I had lain.
Exposed on a slab of stone,
they found me on a fossil hunt,
but were puzzled by my bones,
which seemed back to front.
Eventually they dug out all of me,
entombed in the cliff face,
and sailed me across the sea
to a much safer place.

continued over

And there they pieced me back together
and cleaned me up for show,
flippers and all, back the way they were
two hundred million years ago.
Now I rest at Charmouth
on display for all to see,
a sea dragon brought back to life
from the ancient Jurassic sea.

People Real and Imagined

On one of our many walks along the Dorset coast path, we spotted a National Trust vehicle at the bottom of a slope near Golden Cap. The Ranger had left his van and was climbing purposefully towards a seemingly impenetrable pine wood, to set about his countryside duties. That scene of a lone figure at work in conservation on a cold and blustery day inspired *The Forester*. Similarly, *The Fisherman* at West Bexington always seems to strike a solitary figure, even as he crunches happily on the shingle ridge at Cogden Beach, looking out to sea.

The first time I caught sight of *St Catherine's Chapel* on the hill above Abbotsbury in low golden sunlight, was undoubtedly the moment I recognized the scene as one of the finest in England. St Catherine is the patron saint of spinsters, and Dorset folklore records a custom of young women climbing to the Chapel on a certain day every year, with a prayer for a husband; here I have weaved that prayer into a poem about this annual pilgrimage.

Moving from the fifteenth century to the early nineteenth century, brings me to a remarkable young woman, *Mary Anning*. Anning (1799-1847) was born in Lyme Regis, and at a very young age became an important fossil collector, dealer and palaeontologist, known around the world for her important fossil finds in the Jurassic marine beds. She was born to a cabinet-maker in a house on the site of the Lyme Regis Museum; the house was her home and fossil shop until 1826. Her discoveries include the first recognized ichthyosaur, plesiosaur and flying reptile (see also Sea Dragon on page 17).

It was certain that Thomas Hardy, one of my favourite poets, would feature at least once in this book (see also pages 69 and 75)! Here, my *Ode to Hardy* is something of a medley of some of his poems. Although much of his work

can be considered to be melancholy, the heart soars with his bursts of 'joy illimited', as in The Darkling Thrush. Another notable author, John Fowles, lived for much of his life in Lyme Regis. *Fowles' Undercliff* was inspired by the 1981 film The French Lieutenant's Woman, from Fowles' book of the same name. You can almost smell the humid, peaty banks of the Undercliffs Reserve in the opening lines, which contrasts with a verse alluding to Charles Smithson's infatuation with the object of his desire.

Fowles' Undercliff

And here where the land has slipped away,
long discarded from man's employ,
a dense undergrowth has invaded
moist gullies and chasms.
A climax woodland clings to peaty banks;
ash and maple clasp overhead
to bathe the sunlight,
and a humid forest lair nourishes the fern's tongue.
The sharp trill from the wren's swollen breast
pierces nature's damp silence,
and the wanderer is enfolded in the splendour
of this den of earthy redolence.

Once I had caught sight
of her dark and heavy skirts
moving between the trees,
I followed her urgently.
My interest in wild Undercliff forgotten,
binoculars and knapsack swung from my shoulders.
Even in this humid bower,
twigs cracked drily underfoot,
forewarning my eager pursuit.
And at last she dropped to the ground
in a clearing,
her long skirts ballooning with the fall.
Escaping strands of her titian hair
framing her face in the sunlight,
coquettishly she lifted a hand to her brow.
And her beauty was so dazzling
that I hesitated to step closer.

The Forester

We saw him trudge an upward track
 past hedgerows of yellowing hazel
and umber verges
of autumn's tartan fields.
Alone
he entered the dark planting,
where firs semper viridis
stand too close
and shut out the light,
and collude with the wind
to scorn bold trespass,
and live alone
and make barren
the needled floor
that cracks underfoot.

And so we turned away
and bent towards sharp showers
that stung our faces,
pushing our way
through the prickled paths
of senescing gorse and blackthorn
and up to Golden Cap.

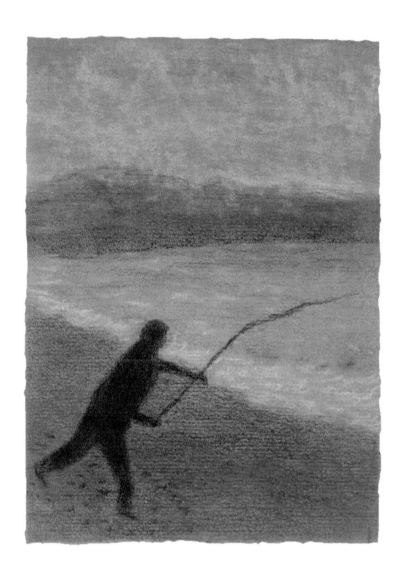

The Fisherman

On a calm day at Cogden Beach
the surf circles onto the shingle
like scalloped lace.
The fisherman's line arcs through clear air,
quivering as it enters the burgeoning swell,
hoping to hook silver scales.
He stands patiently on the pebbled ridge
in waders too big for him,
stones crunching underfoot.
The roll-neck of his gansey
chafing at his beard.
The fisherman next to him
stares straight out to sea.

St Catherine's Chapel

St Catherine of Alexandria -
every year we women of Abbotsbury
climb over heathered hills,
and up to your sanctuary,
guardian of the Fleet and Chesil bank.
Bring me a husband St Catherine.

St Catherine of Alexandria -
patron saint of spinsters,
this chapel was built for you
by the monks of the abbey,
in quiet prominence.
Bring me a handsome one St Catherine.

St Catherine of Alexandria -
this shrine recalls
your monastery on Mount Sinai,
hewn of barren rock,
a place of pilgrimage.
Bring me a rich one St Catherine.

St Catherine of Alexandria -
you survived
the fall of the monasteries
as a beacon of hope.
Bring me a nice one St Catherine.
And bring him to me soon St Catherine.

Mary Anning

" She sells seashells on the seashore
The shells she sells are seashells, I'm sure
So if she sells seashells on the seashore
Then I'm sure she sells seashore shells."

*(Terry Sullivan's lyrics to the 1908 song about Anning,
which became a popular tongue twister.)*

Lightning struck her once
as it cleaved a washed-out sky, and burned to coal
her mistaken shelter of a dark tree –
storm-disturbed and swirling
against the bright white light.
Its energy never left her,
bringing spirit to a sickly child!

And as she looked this way and that,
searching for her 'curies'
snatched from the fallen masses of the hanging cliffs of Lyme
before their entombment by landslip
or engulfment by the quick returning tide,
she felt lightning strike
with each fossil discovery!
And so it was that she pieced together
the first 'crocodiles',
and with sharpened eye,
gathered the finest 'snake-stones'
and 'devil's fingers
from the rubble of the Blue Lias.

*('crocodiles' – ichthyosaurs and plesiosaurs; 'snake-
stones' – ammonites; 'devil's fingers' – belemnites.)*

Inspired by Tracey Chevalier's 2009 historical novel, *Remarkable
Creatures.*

Ode to Hardy

On a morning sick as the day of doom,
in the drizzling gray of an English May,
no bird thrills the shades in the silent glades.
But his Darkling Thrush,
among the bleak twigs overhead,
sings full-hearted of joy illimited!
With love's betrayals he builds the drear,
yet in Proud Songsters he brings us cheer.
While swallows fly o'er the Stour
in June's last beam of the evening hour.
The coomb and the upland coppice-crowned,
shaped as if by a kindly hand,
are for thinking, dreaming, where he stands,
for demons haunt him on the lower lands.
And soon will be growing green blades from her mound,
and daisies be showing like stars on the ground.
Exclaim the sapphire of the wandering sea!
But in its solitude, deep from human vanity,
the wreck of a smart ship, stilly couches she.
Late at night on the Great Western
the journeying boy speeds towards a world unknown,
and calmly takes this plunge alone,
while the words of a child in the waiting room
spread a glory through the gloom.
And through the open window on a sultry eve,
mid his page on new-penned lines,
winged diaphanous guests alight,
'God's humblest they!' I muse. Yet why?
They know Earth-secrets that know not I!

On the Beach

Studland Bay is a large sweeping area of beautiful sandy beaches and dunes with a backdrop of wild heathland, at the very eastern end of the Jurassic Coast. Some visits to Studland Beach on hot, sunny days inspired three poems in this chapter; *Beach Hut* takes a lighthearted look at returning to the family beach home after the winter, while *Windbreak* is rather more moody and thoughtful. *Bucket and Spade* seemed a good topic to explore the villanelle as a poetic form. The villanelle is a poem of nineteen lines, and unlike most rhyming schemes where the sound of single syllables is repeated once or twice, here one sound is repeated thirteen times, and another six. Therein lies the challenge of this lovely form, which is less inclined to narrative, and lends itself more to circling round and round, suggesting mood, emotion and memory.

The concept of longshore drift inspired the poem entitled *Life of a Pebble*. During the course of my research on Chesil Beach, I discovered that pebbles move continually along the shore, as a result of the prevailing wind and waves striking the beach at an angle. Pebbles originate from rock that breaks away at various times in geological history, and as such they colourfully represent many different rock types.

It seems to me that coastal images usually look out to sea away from the land; *From the Deep* is taken from an image that looks back to the shore from a boat at sea, which stimulated a different view of this environment. In contrast, look east or west along the beach on any really stormy day, to experience the exhilaration of the 'salty aerosol from winter's fret' in *Seaspray*.

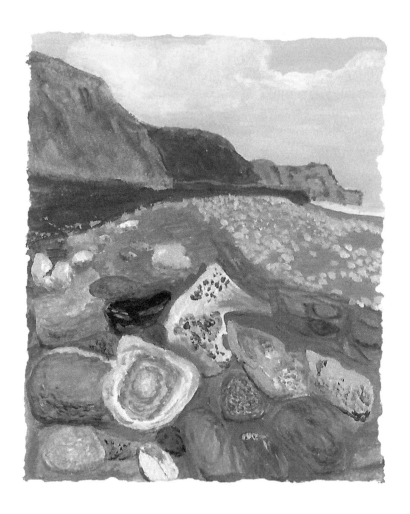

Life of a Pebble

Stones roll, one against another,
a relentless shuffle over long millennia.
Spheres and ovoids collide on the tides,
longshore drift takes them for a ride.
Remorseless waves
spit stones into caves,
toss their load on the beach,
in coves out of reach.
Fragments torn from ancient beds,
veined with quartz in milky threads,
red and pink, ochre and grey,
endless drift from bay to bay.
From Charmouth to Weymouth a shingle skirt
of sandstone, clay, flint and chert.
A pebble cemetery litters the shore,
flung from the billows in jubilant roar!

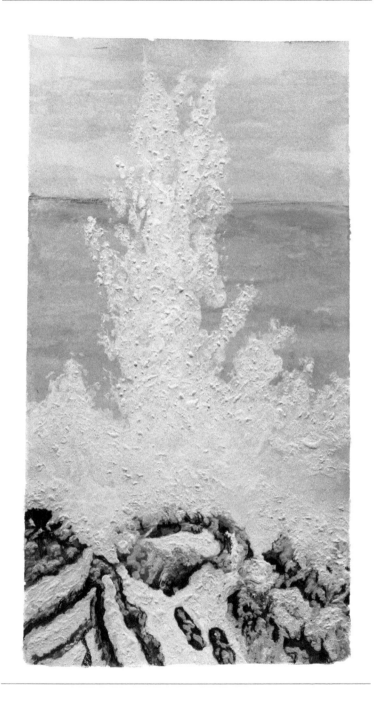

Seaspray

An effervescent spume
erupts from whitecapped waves,
bubbles bursting from foaming crests!
This salty aerosol from winter's fret
mists the shore
like steam on glass.
November's greying brume
is droplet fresh!
Oh the exhilaration of
this sparkling coruscation!

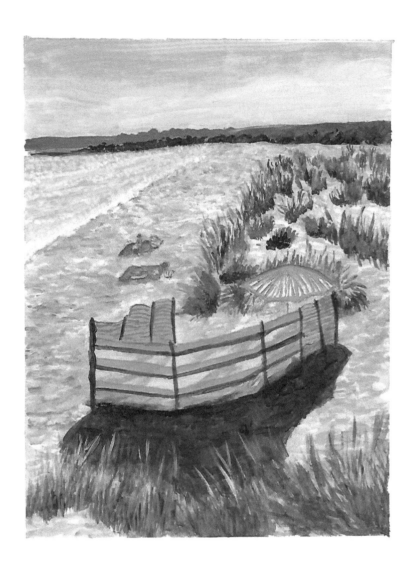

Windbreak

On that day
the heat felt like a blanket smothering us.
We slouched in deckchairs
and pushed our toes into the sand to find cool.
Pitched in the dunes,
the windbreak billowed gently
against tufts of marram grass.
And I wondered why,
as the sun reached its zenith,
why the day trippers,
swarming from the car park,
are drawn to the thin strand and foaming surf,
lying down like sea lions on rocks
with their towels too close
on the scorching quartz.
A return to the shoreline from whence we came?
From the primordial soup?
When prehistoric life crawled out of the sea
to begin its evolutionary lineage?
And the tufts of marram grass,
perfectly evolved for littoral life
with glossy rolled up leaves,
quivered in the breeze,
laughing at the sea lions stranded on the rocks.

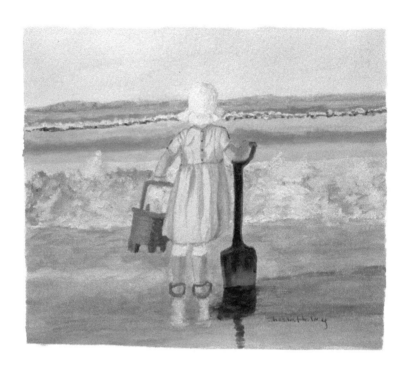

Bucket and Spade

A boy makes castles with a bucket and spade,
a girl in a sunhat has her toes in the sand.
Mum and Dad drink beer in the cool of the shade.

Down on the shingle, towels are carefully laid,
bathers stretched out looking far too tanned.
A boy makes castles with a bucket and spade.

Rockpools and jellyfish, a place we once played,
bright stripey beach huts lining the strand.
Mum and Dad drink beer in the cool of the shade.

Up to our knees in the surf we can wade,
look back from the spray at the old Victorian Grand.
A boy makes castles with a bucket and spade.

The sun sinks low and the light begins to fade,
the brass strikes up on the promenade bandstand.
Mum and Dad drink beer in the cool of the shade.

Fish and chips and ice-cream, we'll wish we had stayed,
a girl in a swimsuit playing in the sand.
A boy makes castles with a bucket and spade,
Mum and Dad drink beer in the cool of the shade.

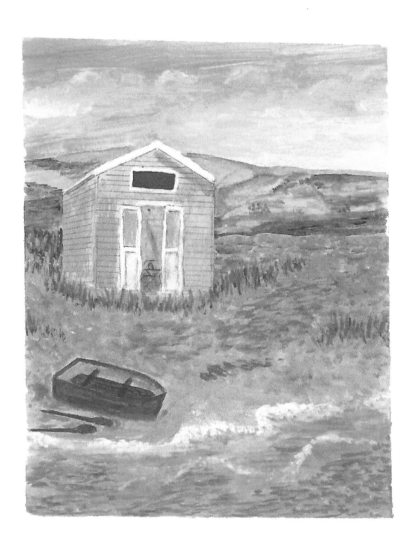

Beach Hut

Spring is here and we feel inclined
to open up the hut,
uncertain what we'll find
after months of being shut.
Paint peeling slightly
and a very stiff lock,
the windows look rather dirty
and the roof has taken a knock.
We fling the doors open,
let out the stale air,
clean the Baby Belling oven,
dust off the stack of chairs.
The tablecloth is still sticky,
coffee cups are home to spiders,
the floorboards are mucky as can be.
Oh! The neighbours will chide us!
Never mind, the kettle is on,
and the deck chairs are set out,
let's have some tea and scones
and enjoy our beachy hideout.

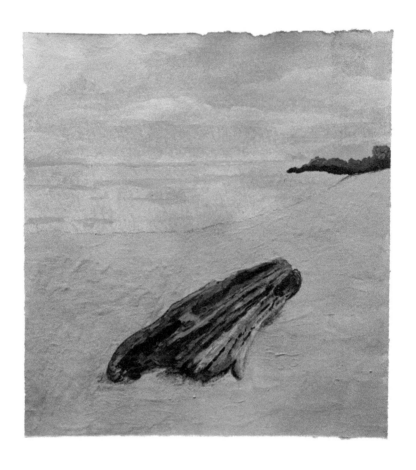

Driftwood

I lie here,
on a pebbled shore,
washed-up
from my wave-borne travels.
Denuded and grey,
parched and smoothed,
I look like an animal carcass.

Driftwood I might be,
but Norse mythology has it
that their Gods
created the first mortals
from remnants of ash and elm
left languishing on the seashore!
And before making landfall,
Viking ships cast lumber into the ocean,
and where the jetsam came to rest,
there the Norsemen
built the great mead halls!
Halls of kings!

From the Deep

Afloat out here,
the inky swell
is at once tranquil and treacherous;
moon-motioned billows rock gently
over unseeable, unfathomable depths
that lie beneath.
Laminarial salt splashes on the tongue,
we blink from the stinging seaspray.
Beyond to the littoral shallows,
the brine sucks as it retreats,
frothing and fizzing,
swirling into silt-made burrows;
the tide is losing its grip.
Tangled bladderwrack
laces a pebble-crested ridge,
and bivalve detritus is washed up
into a last gasp of breath.

Hive Beach Cafe in Winter

A plastic marquee flapping in the wind,
it doesn't look all that inviting,
but wander across the beach and you will find,
patio heaters aglow and a menu that's enticing.
The well-heeled are huddled
in Barbours and Burberry scarves,
on Provencal rose they're sozzled,
and they definitely won't starve.
Mackerel and mussels in a seafood platter,
just what you'd expect on the Dorset coast,
Heritage tomatoes and West Bay lobster,
but don't expect to order a large Sunday roast.
More likely fish and chips in rich tempura batter,
bit of an indulgence, but heck what does it matter?

Coastal Marvels

In this chapter I have collected together some gems that didn't naturally fit elsewhere.

The Poet Samuel Taylor Coleridge (1772-1834) was born in Ottery St Mary, Devon, and wrote a lovely sonnet to the River Otter, a starting point for my poem here on *The Otter Estuary* (though not in sonnet form!). Notable along the sandy path, shaped like a hairpin as it walks inland following the Estuary, are the flocks of geese and other birds enjoying sanctuary on the saltmarshes that flank the water. Another coastal sanctuary for birds is provided by the West Bexington Nature Reserve, featured here in *West Bexington*. As soon as you take the turning off the B3157 for this little village, a feeling of wildness descends as one weaves down through the lanes to the perfectly positioned Manor Hotel, and Beach Road with its pretty bungalows; the 'flap of the nesting kestrel' across the nature reserve inspired the poem on page 57.

Although *Dancing Ledge* lies on perhaps rather bleak quarried Purbeck stone, the beauty of this coastal marvel lies in the fact that at certain tidal points, waves crash over the horizontal rock surface, undulations in which cause the water to bob about as if the ledge is dancing. A swimming pool was blasted into the rock for the use of local schools, sometime in the early twentieth century, and has the appearance of a plunge pool.

As a parting shot, I would recommend a summer's day relaxing at Sidmouth Cricket Club, where you will not only hear the sound of leather on willow, tennis balls being struck, and croquet balls flying through hoops, but have a commanding view of the sea as well (*Colours of Sidmouth*).

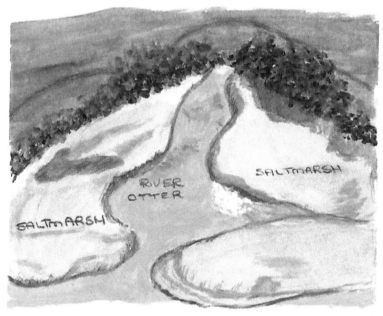

SHINGLE RIDGE

The Otter Estuary

Coleridge wrote a sonnet to the River Otter,
Spoke to us of the bright transparent water,
the gleaming tints from the bedded sands,
the leaps from the skimming stone as it left his hand,
and the willowed banks of his native brook.
Across the saltmarsh a sandy path we took,
and found our own delight in the Otter Estuary,
watching from afar the waders in sanctuary,
and geese curling their necks to sift food from the silt.
We heard cries on the breeze of a happy tumult
of curlews probing the water's edge,
and warblers twittering in reed and sedge.
How wondrous Coleridge's wild stream of the west!
And its refuge for wildlife where it comes to rest.

Dancing Ledge

The boy, pale with youth, and blue with cold,
 trails over stony fields
and edges along the old quarryman's path
above the sea.
Shivering, he clutches a towel,
loose flannel trunks hanging from his scrawny buttocks.
The stonechats call him on,
swaying from their lookout posts
high in the gorse.
He scrambles down to the Ledge,
and at last
sinks into the cyan, deep and still.
Crimson sea anemones
and acid-green ribbons of lettuce
flicker and smile
through the moveless water of the rock pool.
Seawater dances over the hollows,
and a sudden wave takes his breath away.

West Bexington

Where the Spit begins to dwindle
 at the western end of Chesil,
the landward rolling shingle
meets land once agricultural.
Now the lanes from Puncknowle
thread past fields of thistle,
meadows of yellow rattle,
and paths fringed with bramble.
Beach bungalows down the middle
line a slope to the sea quite gentle,
where children go for a paddle,
and fishermen hope for mackerel.
Occasional Anning fossils,
entombed in large grey pebbles,
are probed by tottering whimbrels
dodging tides of frothing circles.
Hear the screech of the hungry seagull
and the flap of the nesting kestrel,
across the reserve to a coastal idyll
where the Spit begins to dwindle.

Colours of Sidmouth

In deckchairs on the boundary line,
we sat with a bottle of crisp white wine.
The sky met the pitch, blue into green,
the sea on the horizon in between.

Silver-haired gents in slacks and blazers,
the ball's red smudge on the bowler's trouser.
Bails flying high to a loud 'howzat'!
The quintessential sound of leather on a bat.

Beyond the wire netting, a different pitch,
a game that was once the preserve of the rich.
Four wooden balls of yellow and red, blue and black,
a mallet and hoops and a competitive knack!

There's a lawn tennis court, if weather permits,
hard courts too, all of them floodlit.
Fluffy balls of fluorescent yellow
don't play in the rain 'cos of tennis elbow.

We sank down further in our stripey deckchairs,
with no desire to look elsewhere.
A thwok and a crack in the clear summer air,
time to enjoy and just stop and stare.

Haiku – Seascape in Four Seasons

Walk the grassy cliffs
pink with thrift and scabious;
the tourists are coming.

Blue sky meets blue sea,
gulls soaring on the thermals.
No room on the beach.

Leaves on the coast path,
beach cafe in golden light.
The days are shortening.

Big froth-filled waves
crashing onto the sea wall;
a cold grey seascape.

Swan Lake
(The Swannery at Abbotsbury)

Down here at the Fleet lagoon,
 hundreds of swans are bobbing together like dodgems
curling their necks into the water,
white like U-bends,
to sift the silt and suck.
The shore is grey-frothed with cygnet down.
And in the withy-beds,
she is proud on her nest,
not a hidden lair,
but a throne of twigs for all to see.
And she gently tap, tap, taps
her sage-green eggs.

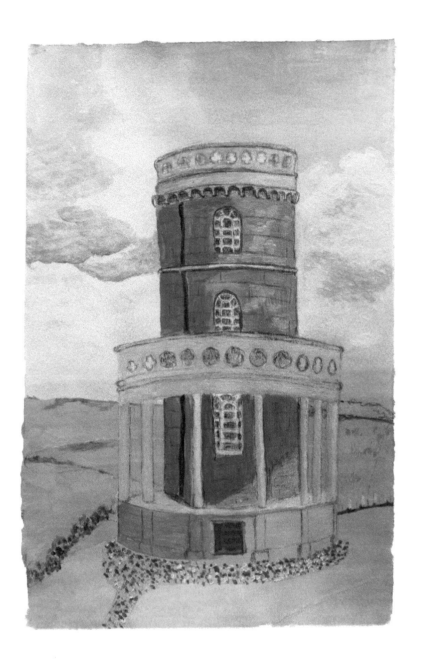

Clavell's Tower

High up on Hen Cliff
stands a Tuscan-style folly,
built by a man of the cloth
around eighteen thirty.

It's a four-floored rotunda
overlooking the bay,
like the turrets in Bologna,
possibly a lookout, in its day.

It boasts a colonnade,
and a parapet on the roof,
on the ground floor, stone was laid,
the rest was made of wood.

A place of romance,
Hardy took his loves there,
as a hermitage it enchants,
it's a monument and a lair.

Nearly two hundred years on,
with the cliff edge crumbling,
and landslip into the ocean,
the folly was near to falling.

So the beautiful tower,
now Grade II listed,
moved inland a little further,
it was carefully shifted.

continued over

The folly hasn't moved far,
about eighty feet,
you can reach it in the car,
it's the perfect retreat.

Owned by the Landmark Trust,
it's a holiday home for two,
for the coastal walker a must,
with a three-hundred-and-sixty degree view.

Going Inland

In this chapter we stray inland from the coast – a worthwhile deviation I think, for the topics contained therein.

To return to my love of Hardy's work, I hugely enjoyed composing the piece entitled *Far from the Madding Crowd*. Whilst doing a little research on the wild areas surrounding Hardy's birthplace in Bockhampton, I discovered a world of lost Dorset dialect; these 'lost words' were perfect for describing Thorncombe Wood, Puddletown Forest and the fictional Egdon Heath, around his cottage (there's a glossary at the end of the book!). In the separate poem, *Hardy's Cottage*, the pantoum form emphasizes the wild beauty of his cottage garden through the ages.

If you haven't visited *The Square and Compass* in the lovely village of Worth Matravers near Swanage, I can certainly recommend it – reputedly the oldest pub in Dorset, it's definitely a place to get chatting to locals and tourists alike. It's walking distance from either the Dorset coast path, or the wonderful Corfe Castle.

We return to Lyme Regis, one of my favourite towns by the sea, for *The Shop of Beautiful Things* and the *Seaside Hotel*. A lighthearted fourteen lines each, with an aabb rhyming scheme, they are evocative of the lovely experiences to be enjoyed in Lyme. Meanwhile, the *B3157* from Weymouth to Bridport is a real 'switchback ride' with wonderful views everywhere you look. It must surely be one of the most picturesque road-trips in southern England.

Hardy's Cottage

Now the flowers bloom and scent every year,
in a garden that was wild two hundred year ago.
And still the birds sing their unchanged song,
from o'ergrown bramble, furze and stunted thorn.

Wild it was two hundred year ago,
our friends were heathcroppers, bats and summer swarms,
among o'ergrown brambles, furze and stunted thorn,
criss-crossed with paths o'erbowered with ferns.

Our friends were heathcroppers, bats and summer swarms.
One hundred year on and the heath is still a wilderness,
with chalky paths o'erbowered with ferns.
But red roses, lilac and honeyzuck have blossomed.

One hundred year on the heath is still a wilderness,
but we have an orchard of Pippins, Scarlets and
 Bockhampton Sweets,
red roses, lilac and honeyzuck have blossomed,
and there's a vegetable garden of herbs and esculents.

An orchard of Pippins, Scarlets and Bockhampton Sweets;
Oh! Those goldening days of cider-making!
And there's a vegetable garden of herbs and esculents,
today brimming with rosemary, sweet pea and lavender.

Oh! Those ripening days of cider-making!
Daisies, hollyhocks and swaying cornflower,
the garden is brimming with rosemary, sweet pea and
 lavender.
And butterflies crowd the buddleias.

continued over

Daisies, hollyhocks and swaying cornflower,
still the birds sing their unchanged song,
and butterflies crowd the buddleias.
And the flowers bloom and scent every year.

Seaside Hotel

Crisp white linen and a room with a view,
shabby chic decor in duck-egg blue.
Old Persian rugs shedding their wool,
the polished wood floors smell of my school.
Waiters attend quietly in the orangery,
a glass of crisp rose goes down pleasingly.
The lawns slope away to a blue, blue sea,
there's a tinkling of spoons with afternoon tea.
Out on a sun-lounger made for two,
a birthday treat for me and you.
Dusty old books and a grandfather clock,
a read in the lounge to the sound of tick-tock.
Reminds me of Brookner's Hotel du Lac,
it's all so romantic we know we'll be back.

The Square and Compass

Is this the oldest pub in Dorset?
No bar, but scrumpy through the hatch,
a gem in Worth Matravers' hamlet,
with an ambience to match.
Stone-floored parlours yellowed with age,
like an old front room in a sepia photo,
step back in time in a hostelry unchanged,
with a view to the sea over the hedgerow.
Known locally as the stonemason's pub,
the punters always have stories to tell,
Cornish pasties are the only grub,
so convivial, try calling time with a bell!
Plants pots and window frames in cobalt blue,
pumpkins on the porch and over the fireplace.
A pit-stop for walkers passing through,
take care entering, there's not much headspace!
Is this the oldest pub in Dorset?
Who knows, it's certainly worth a visit.

Far from the Madding Crowd

On a rale south from the cottage,
through a rottletrap hatch,
lies the furzy, briary wilderness
that is my Egdon Heath.

Out in the cowleaze
clumped with greygole and gilcup,
gallycrows seem to wave
amid barken all a-quob!

Heathcropper and nirrup graze the parrick,
and o'er the wall an archet is strewn with blooth,
from cherry and trailing honeyzuck,
humming with wopsy and dumbledore.

The drongway winds between swallet holes
filled with chump and aller all a-cockle,
where biddle, emmet and moud
have all made their home.

And near the Roman road
is Rushy Pond,
where hoss-stingers hang in moveless air,
and the airmouse flits at dusk.

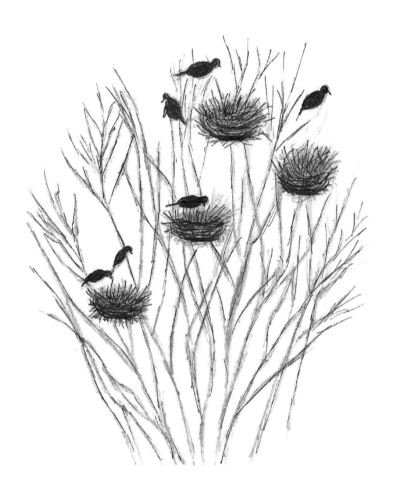

Rooks and Crows

In winter,
crows fly up
from dendritic blackthorns
in their ones and twos;
inkblots against washed-out skies.
Harbingers of doom
with a rasping call.

While rooks
caw harshly
from poplars
waving on the edge of farmland;
their branches balled with untidy nests.
Like rough-coated viruses
clinging to their hosts.

And from their twigged
and noisy communes,
they deceive us
with a raven-like croak
that carries on the wind.

The Shop of Beautiful Things

I know of a little shop in Lyme,
good for a browse if you have the time.
For the minute I forget its name,
I think it's on the corner of a lane.
Vivid artworks, and etchings on slate,
hares in bronze, and sculptures quite ornate.
Papery lanterns and colourful kites,
polished gems and lots of ammonites.
The doorbell jangles and shoppers walk in,
squeezing past each other, not touching a thing.
Popped in a paper bag a necklace of shells,
I wonder how many of those she sells.
I know of a little shop in Lyme,
do drop in if you have the time.

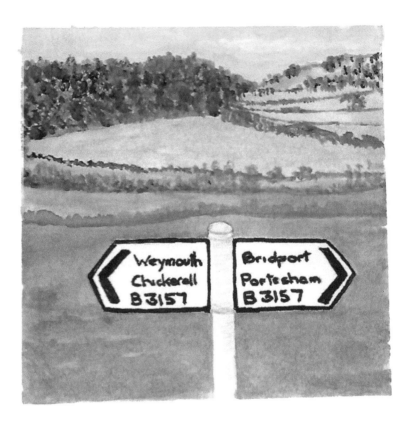

B3157

There's a brown road on the Ordnance Survey,
a switchback ride with fabulous views,
runs like a ribbon from Weymouth to West Bay,
and with any luck, very few queues.
From Chickerell and Langton Herring,
the B3157 curves through Portesham,
a popular village with folks just visiting,
the pub on the corner serving local lamb.
It snakes its way through Abbotsbury,
downhill from a Sarsen boulder train,
skirts the Chapel and the Swannery,
across a heath of gorse, in the main.
Admiral Hardy has a breathtaking view,
across to Chesil Beach, a very long Spit
that strikes out across a lagoon so blue,
a unique ridge of shingle and grit.
Further over is Little Bredy,
walk from here to the Valley of the Stones,
and then there's picturesque Litton Cheney,
pop in to the village cafe for tea and scones.
Down in the dip near Puncknowle and Swyre,
turn off left for the Manor Hotel,
it's a very good spot from which to admire
the beach road leading to the briney swell.
So fasten your seatbelts and enjoy the ride,
one of the best road-trips in England – you decide!

A Bit of History

It is perhaps no coincidence that two of the poems in this section are pantoums, and there is also a villanelle; of all the verse forms the pantoum is the slowest, it steps forward and then steps back and is the perfect form for the evocation of a past time. As with the villanelle, there is the possibility to evoke time in a way that is harder to express with straightforward narrative.

Thus, the fascinating Tyneham village and its occupation by the army in preparation for D-day in the Second World War, are described in the pantoum *Tyneham*, and *The Bindon Landslide* in a second pantoum. The Bindon Landslide in 1839 was an astonishing 'blockslide' of a strip of coast to the west of Lyme Regis. A huge piece of land, known locally as Goat Island, moved towards the sea leaving a deep chasm. This and subsequent landslides have given rise to the Undercliffs National Nature Reserve, which is one of the most important wilderness areas in Britain. The Reserve is also featured in *Fowles' Undercliff* on page 21. The villanelle entitled *Chesil Beach in 1824* also relates to events in the first half of the nineteenth century.

Old Harry Rocks represent the cretaceous chalk at the far eastern end of the Jurassic Coast, the youngest of the rocks at this World Heritage Site, and the subject of the aptly titled *End of an Era*. From the air, the chalk on Ballard Down really does look like the frill on a skirt!

Finally, as a nod to the fast-paced world in which we live, *In a Changing World* recognizes some random observations for which we might be thankful are unchanging!

Tyneham

Please treat the church and houses with care
 We have given up our homes where we lived for
generations
To help win the war to keep men free
We shall return one day, thank you for treating the village
kindly

We gave up our homes where we lived for generations
We left just before Christmas, nineteen-forty-three
We shall return one day, thank you for treating the village
kindly
We were displaced, it was like being evacuated

We left just before Christmas, nineteen-forty-three
We were told we would return, but we never did
We were evacuated, it was like being displaced
The army took over the village that December

We were told we would return, but we never did
The last villager to leave left a note on the church door
The army took over the village that December
It was in preparation for D-day

The last villager to leave left a note on the church door
It was a wartime sacrifice
In preparation for D-day
But the army remained for the Cold War

It was a wartime sacrifice
Two-hundred-and-twenty-five villagers were displaced
And the army remained for the Cold War
But the way we lived has been preserved

continued over

Two-hundred-and-twenty-five villagers were displaced
To help win the war to keep men free
But the way we lived has been preserved
Please treat the church and houses with care

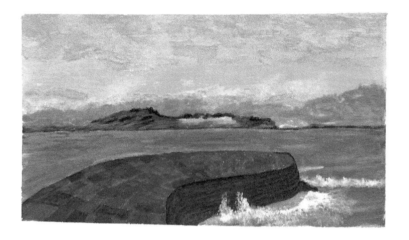

The Cobb

Once upon a time,
this little port of Lyme
was nestled in the shelter
of a breakwater shaped like a demi-lune;

huge oak stakes driven into the seabed
were filled high with boulders,
like fruit in a basket,
with not an ounce of cement between stones.

Tides played the crevices,
over and over,
until stone and oak were swept away,
and boats swivelled helplessly on the swell.

But now, this invulnerable sea defence
of Portland stone and mortar,
curling round the harbour like a scythe,
will not give way to the might of the ocean.

The swell sucks at the slimed walls -
slimed from invertebrate life clinging to the stones
between the slappings from every moon-motioned surge;
and waves are tossed in the air
like soldiers shot from their steeds.

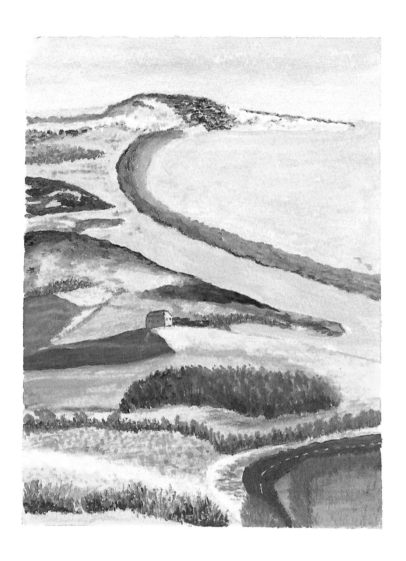

Chesil Beach in 1824

We ran for our lives until we were beat,
 from a storm driven on by winds from the west.
The surge breached the Spit and swallowed up the Fleet.

We had stood by the cattle pound but now turned in retreat,
away from the wave bearing boats on its crest!
We ran for our lives away from the Fleet.

Houses swept away, the destruction was complete,
as the wave pushed forwards, foam on its breast,
breaching the Spit and engulfing the Fleet.

A fallen church where land and lagoon meet,
a village in ruins from nature's unwelcome guest.
We ran for our lives in desperate retreat.

Reaching Chickerell, dead on our feet,
luckily we were saved, we were certainly blessed.
The surge breached the Spit and swallowed up the Fleet.

In two hundred years we've not seen a repeat
of the relentless rage in a hurricane's quest.
We ran for our lives until we were beat.
The surge breached the Spit engulfing the Fleet.

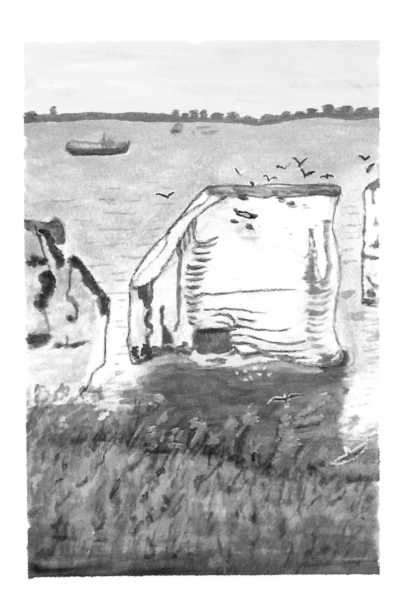

End of an Era

The frill on the skirt of Ballard Down,
at the end of the coast of world renown

is the chalk of Old Harry and his wife,
joined to the Isle of Wight in a previous life.

Now it's a family of mighty white stacks,
with grassy tops and flint in the cracks.

The skirt of chalk curves away,
meeting the sea at Worbarrow Bay.

The ridge marks the end of an ancient era,
maybe caused by a giant meteor;

a momentous event in the history of the Earth,
that sparked Old Harry's family's birth.

Was Old Harry the devil who slept on the rocks?
Or Harold the Earl, the pillar of chalk?

Who knows the legend of these brilliant white blocks,
But Old Harry Rocks, they really do rock!

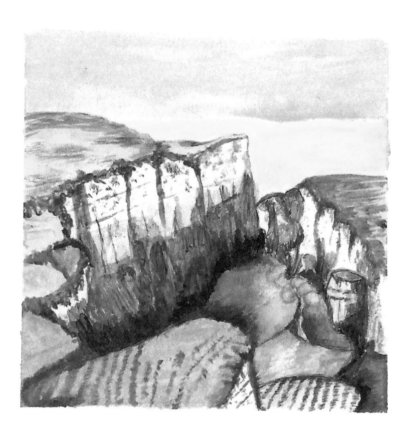

The Bindon Landslide

That Christmas in eighteen-thirty-nine,
on a night of engulfing dark,
something vast and monstrous
stirred beneath the sea.

On a night of engulfing dark,
the shore in heaving motion,
something stirred beneath the sea,
convulsing from the depths.

The shore in heaving motion,
a hideous rise and fall,
a convulsion from the depths,
like a gigantic reef appearing.

A hideous rise and fall of
a stupendous lias ridge,
like a gigantic reef appearing,
opening in ugly rupture.

A stupendous lias ridge,
like the ravages of an earthquake
opening in ugly rupture,
causing coastal chaos.

Like the ravages of an earthquake,
it drew attention from the nation,
to the coastal chaos
that was the Bindon landslide.

continued over

It drew attention from the nation,
tourists arrived on paddle steamers
to see the Bindon landslide,
and the famed Goat Island.

Tourists arrived on paddle steamers
to admire the grand disturbance,
and the famed Goat Island,
now a wilderness of trees.

And this grand disturbance,
now the Undercliffs Reserve,
is a wilderness of trees
that conceals a monstrous uprising.

And so the Undercliffs Reserve,
once a gaping chasm,
conceals the monstrous uprising
of that Christmas in eighteen-thirty-nine.

In a changing world

I'm so glad...
... roses smell the same as they did in my parents' garden
... the ice-cream van still plays Greensleeves
... the song of a bird never changes
... my feet still look the same
... pastoral scenes haven't changed since Landseer
... a tin of loose-leaf tea always smells good
... people still write letters
... flowers still bloom at the same time every year
... cake mixture tastes the same as it did when I was a child
... a bed still looks like a bed
... the baker's window still has currant buns, éclairs and
 doughnuts
... a giggling child still sounds the same
... the leaves still fall in autumn
... people still love books
... some things never change...

Glossary – Dorset Dialect

A-cockle, *tangle*
Airmouse, *bat*
Aller, *alder tree*
A-quob, *quiver, wave*
Archet, *orchard*
Barken, *barley*
Biddle, *beetle*
Blooth, *blossom*
Chump, *logs*
Cowleaze, *meadow*
Drongway, *narrow footpath*
Dumbledore, *bumblebee*
Emmet, *ant*
Gallycrow, *scarecrow*
Gilcup, *buttercup*
Greygole, *bluebell*
Hethcropper, *horse or pony bred on a heath*
Honeyzuck, *honeysuckle*
Hoss-stinger, *dragonfly*
Moud, *field mouse*
Nirrup, *donkey*
Parrick, *paddock*
Rale, *walk*
Rottletrap hatch, *rickety gate*
Swallet, *opening*
Wopsy, *wasp*

About the Author

Amanda Kirkland Hampson (née Adams) was born in 1959, and lived in Leigh-on-sea in Essex before attending University College Swansea, and subsequently the University of Aston in Birmingham, to study environmental biology. After a career principally as an editor in science and medicine, spanning over three decades, Amanda retired in 2015. Her professional life included several years as an editor at *The Lancet* medical journal, and work abroad in over 20 countries. In contrast to her working life, she is now delightfully engaged in various branches of the Arts, and is also a keen walker and tennis player. She has lived in Wiltshire with her husband Keith since 2013.

AKHampsonPoetry@gmail.com
https://www.akhampson.uk

The Artist

Sheila Haley has lived in the Vale of Pewsey, Wiltshire for nearly twenty years. After retiring from a long service in schools administration, she joined a local group "So you think you can't draw!" where she discovered her gift for painting and drawing. Sheila has found the countryside and her love of village life are strong inspirations for her art works, and her varied and detailed illustrations beautifully accompany the poems in this book. Sheila enjoys a very busy and active retirement – she has been involved in community projects and was a police chaplain, and she is also a keen badminton and table tennis player. In addition, Sheila enjoys spending time with her three children and grandchildren.

Lightning Source UK Ltd.
Milton Keynes UK
UKHW021023250721
387657UK00007B/86